CW00419284

1 MONTH OF
FREE
READING

at

www.ForgottenBooks.com

By purchasing this book you are eligible for one month membership to ForgottenBooks.com, giving you unlimited access to our entire collection of over 700,000 titles via our web site and mobile apps.

To claim your free month visit:

www.forgottenbooks.com/free31852

ISBN 978-0-265-66045-4
PIBN 10031852

THE FORUM EXHIBITION OF MODERN AMERICAN PAINTERS /

MARCH THIRTEENTH TO MARCH TWENTY-FIFTH, 1916

COMMITTEE

DR. CHRISTIAN BRINTON ALFRED STIEGLITZ

ROBERT HENRI DR. JOHN WEICHSEL

W. H. DE B. NELSON WILLARD HUNTINGTON WRIGHT

ARTISTS

BEN BENN ALFRED MAURER

THOMAS H. BENTON HENRY L. McFEE

OSCAR BLUEMNER GEORGE F. OF

ANDREW DASBURG MAN RAY

ARTHUR G. DOVE MORGAN RUSSELL

MARSDEN HARTLEY CHARLES SHEELER

S. MACDONALD-WRIGHT A. WALKOWITZ

JOHN MARIN WM. AND MARGUERITE ZORACH

ON VIEW AT THE ANDERSON GALLERIES
FIFTEEN EAST FORTIETH STREET, NEW YORK

COPYRIGHT 1916 BY
MITCHELL KENNERLEY

PRINTED IN AMERICA

IN EXPLANATION

THE object of the present exhibition is to put before the American public in a large and complete manner the very best examples of the more modern American art; to stimulate interest in the really good native work of this movement; to present for the first time a comprehensive, critical selection of the serious painting now being shown in isolated groups; to turn public attention for the moment from European art and concentrate it on the excellent work being done in America; and to bring serious, deserving painters in direct contact with the public without a commercial intermediary.

SELECTION

Out of fifty names of the most deserving very modern American painters, the Committee has selected the sixteen names here represented; and from the large number of paintings submitted, the Committee has chosen the works now on view. Thus not only are the artists chosen for their merit, but the works also represent what, in the eyes of the Committee, are the best paintings of each artist.

THE COMMITTEE

The Forum Committee is composed of six men actively interested in art—men who hold high positions in their respective fields in America.

Dr. Christian Brinton has for many years been one of the foremost American critics and lecturers on international art. He is the author of *Modern Artists, Impressions of the Art at the Panama-Pacific Exposition*, and many other works on painting; he is Advisory Editor of *Art in America*, and a regular contributor to the leading art journals.

Robert Henri is an artist of international reputation. His paintings are represented in the Luxembourg Gallery, the Metro-

politan Museum, and many other permanent collections. He is a member of the National Academy, the National Institute of Arts and Letters, etc.

W. H. de B. Nelson is the editor of the *International Studio;* a painter, and a lecturer on art.

Alfred Stieglitz is the editor and publisher of *Camera Work,* and the leading spirit of "291." At 291 Fifth Avenue the pioneer work for the recognition of modern art in America was begun in 1906.

Dr. John Weichsel is the President of the People's Art Guild, the largest enterprise of its kind in the world.

Willard Huntington Wright is the art critic of the *Forum,* and contributing art critic of the *International Studio.* He is the author of *Modern Painting: Its Tendency and Meaning.*

The Committee have no financial interest whatever in this exhibition. Their services have been given free. They have been animated solely by the desire to counteract the prevailing prejudices against modern painting, and to create an intelligent interest in deserving artists.

THE BUYING PUBLIC

Art collectors have always been afraid, and in many instances rightly so, to purchase the new works of modern men. Many charlatans have allied themselves with the movement; and because the movement has been so little understood, and because the commercial element has entered into it to so great an extent, buyers have in many instances been unable to differentiate between the sincere and insincere.

But in this exhibition a careful attempt has been made to eliminate the spurious and to present only such work as is truly worth while. Every painting here is, after a fashion, vouched for by men whose integrity and knowledge of art are beyond question.

No more genuine art service can be rendered, either to yourself or to the cause of serious art effort in America, than by the purchase of these works.

CONTENTS

REPRODUCTIONS

WHAT IS MODERN PAINTING?

WILLARD HUNTINGTON WRIGHT

WHAT IS MODERN PAINTING?

WILLARD HUNTINGTON WRIGHT

THROUGHOUT the entire history of the fine arts, no period of æsthetic innovation and endeavor has suffered from public malignity, ridicule and ignorance as has painting during the last century. The reasons for this are many and, to the serious student of art history, obvious. The change between the old and the new order came swiftly and precipitously, like a cataclysm in the serenity of a summer night. The classic painters of the first half of the nineteenth century, such as David, Ingres, Gros and Gérard, were busy with their rehabilitation of ancient traditions, when without warning, save for the pale heresies of Constable, a new and rigorous régime was ushered in. It was Turner, Delacroix, Courbet and Daumier who entered the sacred temple, tore down the pillars which had supported it for centuries, and brought the entire structure of established values crashing down about them. They survived the *débâcle,* and when eventually they laid aside their brushes for all time it was with the unassailable knowledge that they had accomplished the greatest and most significant metamorphosis in the history of any art.

But even these hardy anarchists of the new order little dreamed of the extremes to which their heresies would lead. So precipitous and complex has been the evolution of modern painting that few of the most revolutionary moderns have succeeded in keeping mental step with its developments and divagations. During the past few years new modes and manners in art have sprung up with fungus-like rapidity. "Movements" and "schools" have followed one another with astounding pertinacity, each claiming that finality of expression which is the aim of all seekers for truth. And, with but few exceptions, the men who have instigated these innovations have been animated by a serious purpose—that of mastering the problem of æsthetic organization and of circumscribing the one means for obtaining ultimate and indestructible results. But the problems of art, like those of life itself, are in the main unsolvable, and art must ever

be an infinite search for the intractable. Form in painting, like the eternal readjustments and equilibria of life, is but an approximation to stability. The forces in all art are the forces of life, coordinated and organized. No plastic form can exist without rhythm: not rhythm in the superficial harmonic sense, but the rhythm which underlies the great fluctuating and equalizing forces of material existence. Such rhythm is symmetry in movement. On it all form, both in art and life, is founded.

Form in its artistic sense has four interpretations. First, it exhibits itself as shallow imitation of the surface aspects of nature, as in the work of such men as Sargent, Sorolla and Simon. Secondly, it contains qualities of solidity and competent construction such as are found in the paintings of Velazquez, Hogarth and Degas. Thirdly, it is a consummate portrayal of objects into which arbitrary arrangement has been introduced for the accentuation of volume. Raphael, Poussin and Goya exemplify this expression of it. Last, form reveals itself, not as an objective thing, but as an abstract phenomenon capable of giving the sensation of palpability. All great art falls under this final interpretation. But form, to express itself æsthetically, must be composed; and here we touch the controlling basis of all art:— organization. Organization is the use put to form for the production of rhythm. The first step in this process is the construction of line, line being the direction taken by one or more forms. In purely decorative rhythm the lines flow harmoniously from side to side and from top to bottom on a given surface. In the greatest art the lines are bent forward and backward as well as laterally so that, by their orientation in depth, an impression of profundity is added to that of height and breadth. Thus the simple image of decoration is destroyed, and a microcosmos is created in its place. Rhythm then becomes the inevitable adjustment of approaching and receding lines, so that they will reproduce the placements and displacements to be found in the human body when in motion.

To understand, and hence fully to appreciate, a painting, we must be able to recognize its inherent qualities by the process of intellectual reasoning. By this is not implied mechanical or scientific observation. Were this necessary, art would resolve itself

into a provable theory and would produce in us only such mental pleasure as we feel before a perfect piece of intricate machinery. But once we comprehend those constitutional qualities which pervade all great works of art, plastic and graphic, the sensuous emotion will follow so rapidly as to give the effect of spontaneity. This process of conscious observation in time becomes automatic and exerts itself on every work of art we inspect. Once adjusted to an assimilation of the rhythmic compositions of El Greco and Rubens, we have become susceptible to the tactile sensation of form in all painting. And this subjective emotion is keener than the superficial sensation aroused by the prettiness of design, the narrative of subject-matter, or the quasi-realities of transcription. More and more as we proximate to a true understanding of the principles of art, shall we react to those deeper and larger qualities in a painting which are not to be found in its documentary and technical side. Also our concern with the transient sentiments engendered by a picture's external aspects will become less and less significant. Technique, dramatic feeling, subject, and even acuracy of drawing, will be relegated to the subsidiary and comparatively unimportant position they hold in relation to a painting's *æsthetic* purpose.

The lack of comprehension—and consequently the ridicule—which has met the efforts of modern painters, is attributable not alone to a misunderstanding of their seemingly extravagant and eccentric mannerisms, but also to an ignorance of the basic postulates of all great art both ancient and modern. Proof of this is afforded by the constant statements of preference for the least effectual of older painters over the greatest of the moderns. These preferences, if they are symptomatic of aught save the mere habit of a mind immersed in tradition, indicate an immaturity of artistic judgment which places prettiness above beauty, and sentimentality and documentary interest above subjectivity of emotion. The fallacies of such judgment can best be indicated by a parallel consideration of painters widely separated as to merit, but in whom these different qualities are found. For instance, the prettiness of Reynolds, Greuze and Murillo is as marked as the prettiness of Titian, Giorgione and Renoir. The latter are by far the greater artists; yet, had we no other critical

standard save that of charm, the difference between them and the others would be indistinguishable. Zuloaga, Whistler, Botticelli and Böcklin are as inspirational of sentiment as Tintoretto, Corot, Raphael and Poussin; but by no authentic criterion are they as great painters. Again, were drama and simple narrative æsthetic considerations, Regnault, Brangwyn, and Antonio Molineri would rank with Valerio Castello, Rubens and Ribera.

In one's failure to distinguish between the apparent and the organic purposes of art lies the greatest obstacle to an appreciation of what has come to be called modern painting. The truths of modern art are no different from those of ancient art. A Cézanne landscape is not dissimilar in aim to an El Greco. The one is merely more advanced as to methods than the other. Nor do the canvases of the most ultra-modern schools strive toward an æsthetic manifestation radically unlike that aspired to in Michelangelo's *Slaves*. Serious modern art, despite its often formidable and bizarre appearance, is only a striving to rehabilitate the natural and unalterable principles of rhythmic form to be found in the old masters, and to translate them into relative and more comprehensive terms. We have the same animating ideal in the pictures of Giotto and Matisse, Rembrandt and Renoir, Botticelli and Gauguin, Watteau and Picasso, Poussin and Friesz, Raphael and Severini. The later men differ from their antecedents in that they apply new and more vital methods to their work. Modern art is the logical and natural outgrowth of ancient art; it is the art of yesterday heightened and intensified as the result of systematic and painstaking experimentation in the media of expression.

The search for composition—that is, for perfectly poised form in three dimensions—has been the impelling dictate of all great art. Giotto, El Greco, Masaccio, Tintoretto and Rubens, the greatest of all the old painters, strove continually to attain form as an abstract emotional force. With them the organization of volumes came first. The picture was composed as to line. Out of this grew the subject-matter—a demonstration *a posteriori*. The human figure and the recognizable natural object were only auxiliaries, never the sought-for result. In all this they were inherently modern, as that word should be understood; for

the new conception of art strives more and more for the emotion rather than the appearance of reality. The objects, whether arbitrary or photographic, which an artist uses in a picture are only the material through which plastic form finds expression. They are the means, not the end. If in the works of truly significant art there is a dramatic, narrative or illustrative interest, it will be found to be the incidental and not the important concomitant of the picture.

Therefore it is not remarkable that, with the introduction of new methods, the illustrative side of painting should tend toward minimization. The elimination of all the superfluities from art is but a part of the striving toward defecation. Since the true test of painting lies in its subjective power, modern artists have sought to divorce their work from all considerations other than those directly allied to its primary function. This process of separation advanced hand in hand with the evolution of new methods. First it took the form of the distortion of natural objects. The accidental shape of trees, hills, houses and even human figures was altered in order to draw them into the exact form demanded by the picture's composition. Gradually, by the constant practice of this falsification, objects became almost unrecognizable. In the end the illustrative obstacle was entirely done away with. This was the logical outcome of the sterilizing modern process. To judge a picture competently, one must not consider it as a mere depiction of life or as an anecdote: one must bring to it an intelligence capable of grasping a complicated counterpoint. The attitude of even such men as Celesti, Zanchi, Padovanino and Bononi is never that of an illustrator, in no matter how sublimated a sense, but of a composer whose aim is to create a polymorphic conception with the recognizable materials at hand.

Were art to be judged from the pictorial and realistic viewpoint we might find many meticulous craftsmen of as high an objective efficiency as were the men who stood at the apex of genuine artistic worth—that is, craftsmen who arrived at as close and exact a transcription of nature, who interpreted current moods and mental aspects as accurately, and who set forth superficial emotions as dramatically. Velazquez's *Philip IV*, Titian's

Emperor Charles V, Holbein's *The Ambassadors*, Guardi's *The Grand Canal—Venice*, Mantegna's *The Dead Christ* and Dürer's *Four Naked Women* reproduce their subjects with as much painstaking exactitude as do El Greco's *Resurrection of Christ*, Giotto's *Descent from the Cross*, Masaccio's *Saint Peter Baptising the Pagans*, Tintoretto's *The Miracle of Saint Mark*, Michelangelo's *Creation of the Sun and Moon*, and Rubens's *The Earl and Countess of Arundel*. But these latter pictures are important for other than pictorial reasons. Primarily they are organizations, and as such they are of æsthetic value. Only secondarily are they to be appraised as representations of natural objects. In the pictures of the former list there is no synthetic coördination of tactile forms. Such paintings represent merely " subject-matter " treated capably and effectively. As sheer painting from the artisan's standpoint they are among the finest examples of technical dexterity in art history. But as contributions to the development of a pure art form they are valueless.

In stating that the moderns have changed the quality and not the nature of art, there is no implication that in many instances the great men of the past, even with limited means, have not surpassed in artistic achievement the men of to-day who have at hand more extensive means. Great organizers of plastic form have, because of their tremendous power, done with small means more masterly work than lesser men with large means. For instance, Goya as an artist surpasses Manet, and Rembrandt transcends Daumier. This principle holds true in all the arts. Balzac, ignorant of modern literary methods, is greater than George Moore, a master of modern means. And Beethoven still remains the colossal figure in music, despite the vastly increased modern scope of Richard Strauss's methods. Methods are useless without the creative will. But granting this point (which unconsciously is the stumbling block of nearly all modern art critics), new and fuller means, even in the hands of inferior men, are not the proper subject for ridicule.

It must not be forgotten that the division between old and modern art is not an equal one. Modern art began with Delacroix less than a hundred years ago, while art up to that time had many centuries in which to perfect the possibilities of its re-

sources. The new methods are so young that painters have not had time to acquire that mastery of material without which the highest achievement is impossible. Even in the most praiseworthy modern art we are conscious of that intellectual striving in the handling of new tools which is the appanage of immaturity. Renoir, the greatest exponent of Impressionistic means, found his artistic stride only in his old age, after a long and arduous life of study and experimenting. His canvases since 1905 are the first in which we feel the fluency and power which come only after a slow and sedulous process of osmosis. Compare, for instance, his early and popular *Le Moulin de la Galette* with his later portraits, such as *Madame T. et Son Fils* and *Le Petit Peintre,* and his growth is at once apparent.

The evolution of means is answerable to the same laws as the *progressus* in any other line of human endeavor. The greatest artists are always culminations of long lines of experimentations. In this they are eclectic. The organization of observation is in itself too absorbing a labor to permit of a free exercise of the will to power. The blinding burst of genius at the time of the Renaissance was the breaking forth of the accrued power of generations. Modern art, having no tradition of means, has sapped and dispersed the vitality of its exponents by imposing upon them the necessity for empirical research. It is for this reason that we have no men in modern art who approximate as closely to perfection as did many of the older painters. But had Rubens, with his colossal vision, had access to modern methods his work would have been more powerful in its intensity and more far-reaching in its scope.

However, in the brief period of modern art two decided epochs have been brought to a close through this accumulation and eruption of experimental activities in individuals. Renoir brought to a focus the divergent rays of his predecessors, and terminated that cycle of experimentation and research which started with Delacroix, Turner, Constable, Daumier and Courbet, was carried forward by Manet, developed into Impressionism by Monet, Pissarro, Sisley and Guillaumin, and was later turned into scientific channels by the Neo-Impressionists, Signac, Seurat and Cross. Renoir rejected the fallacies of these earlier

men and made use of their vital discoveries, coördinating and
rationalizing them, and welding them into definite artistic achieve-
ments. The second modern cycle began with Cézanne. Into his
canvases he incorporated the aspirations and accomplishments
of the first cycle, and applied the new methods to the expression
of the rhythmic laws of composition and organization which had
been established by the old masters. He was, as he himself said,
the " primitive " of this new epoch. Henri-Matisse, the Cubists
and the Futurists in turn advanced on Cézanne's procedure, car-
rying his impetus nearer and nearer abstract purity. And a more
recent art school, Synchromism, by making use of the achieve-
ments of Cézanne, Cubism and Michelangelo, and by adding to
them new discoveries in the dynamics of color, has opened up a
new vista of possibilities in the expressing of æsthetic form. In
this last school was completed the second modern cycle. Once
these new modes, which are indicative of modern art, become
understood and pass into the common property of the younger
men, we shall have achievement which will be as complete as
the masterpieces of old, and which will, in addition, be more
poignant.

Although the methods of the older painters were more re-
stricted than those of the moderns, the actual materials at their
disposal were fully as extended as ours of to-day. But knowl-
edge concerning them was incomplete. As a consequence, all
artists antecedent to Delacroix found expression only in those
qualities which are susceptible to reproduction in black and white.
In many cases the sacrifice of color enhances the intrinsic merit
of such reproductions, for often the characteristics of the differ-
ent colors oppose the purposes of a picture's planes. To-day we
know that certain colors are opaque, others transparent; some
approach the eye, others recede. But the ancients were ignorant
of these things, and their canvases contained many contradictions:
there was a continuous warring between linear composition and
color values. They painted solids violet, and transpicuous planes
yellow—thereby unconsciously defeating their own ends, for
violet is limpid, and yellow tangible. In one-tone reproductions
such inconsistencies are eliminated, and the signification of the
picture thereby clarified. It was Rubens who embodied the de-

fined attributes of ancient art in their highest degree of pliability,
and who carried the impulse toward creation to a point of com-
plexity unattained by any other of the older men. In him we see
the culmination of the evolution of linear development of light
and dark. From his time to the accession of the moderns the
ability to organize was on the decrease. There was a weakening
of perception, a decline of the æsthetic faculty. The chaotic
condition of this period was like the darkness which always
broods over the world before some cleansing force sweeps it
clean and ushers in a new and greater cycle.

The period of advancement of these old methods extends
from prehistoric times to the beginning of the nineteenth century.
On the walls of the caverns in Altamira and the Dordogne are
drawings of mammoths, horses and bison in which, despite the
absence of details, the actual approach to nature is at times more
sure and masterly than in the paintings of such highly cultured
men as Botticelli and Pisanello. The action in some of them is
pronounced; and the vision, while simple, is that of men conscious
of a need for compactness and balance. Here the art is simply
one of outline, heavy and prominent at times, light and almost
indistinguishable at others; but this grading of line was the result
of a deeper cause than a tool slipping or refusing to mark. It
was the consequence of a need for rhythm which could be obtained
only by the accentuation of parts. The drawings were generally
single figures, and rarely were more than two conceived as an
inseparable design. Later, the early primitives used symmetrical
groupings for the same purpose of interior decorating. Then
came simple balance, the shifting and disguise of symmetry, and
with it a nearer approach to the *imprévu* of nature. This style
was employed for many generations until the great step was taken
which brought about the Renaissance. The sequential aspect of
line appeared, permitting of rhythm and demanding organization.
Cimabue and Giotto were the most prominent exponents of this
advance. From that time forward the emotion derived from
actual form was looked upon by artists as a necessary adjunct
to a picture. With this attitude came the aristocracy of vision
and the abrogation of painting as mere exalted craftsmanship.

After that the evolution of art was rapid. In the contempla-

tion of solidly and justly painted figures the artist began to extend his mind into space and to use rhythm of line that he might express himself in depth as well as surfacely. Thus he preconized organization in three dimensions, and by so doing opened the door of an infinity of æsthetic ramifications. From the beginning, tone balance—that is, the agreeable distribution of blacks, whites and greys—had gone forward with the development of line, so that with the advent of depth in painting the arrangement of tones became the medium through which all the other qualities were made manifest.

In the strict sense, the art of painting up to a hundred years ago had been only drawing. Color was used only for ornamental or dramatic purposes. After the first simple copying of nature's tints in a wholly restricted manner, the use of color advanced but little. It progressed toward harmony, but its dramatic possibilities were only dimly felt. Consequently its primitive employment for the enhancement of the decorative side of painting was adhered to. This was not because the older painters were without the necessary pigments. Their colors in many instances were brighter and more permanent than ours. But they were satisfied with the effects obtained from black-and-white expression. They looked upon color as a delicacy, an accessory, something to be taken as the gourmet takes dessert. Its true significance was thus obscured beneath the artists' complacency. As great an artist as Giorgione considered it from the conventional viewpoint, and never attempted to deviate toward its profounder meanings. The old masters filled their canvases with shadows and light without suspecting that light itself is simply another name for color.

The history of modern art is broadly the history of the development of form by the means of color—that is to say, modern art tends toward the purification of painting. Color is capable of producing all the effects possible to black and white, and in addition of exciting an emotion more acute. It was only with the advent of Delacroix, the first great modern, that the dramatic qualities of color were intelligently sensed. But even with him the conception was so slight that the effects he attained were but meagrely effective. After Delacroix further experiments in color

led to the realistic translation of certain phases of nature. The old static system of copying trees in green, shadows in black and skies in blue did not, as was commonly believed, produce realism. While superficially nature appeared in the colors indicated, a close observation later revealed the fact that a green tree in any light comprises a diversity of colors, that all sunlit skies have a residue of yellow, and hence that shadows are violet rather than black. This newly unearthed realism of light became the battle cry of the younger men in the late decades of the nineteenth century, and reached parturition in the movement erroneously called Impressionism, a word philologically opposed to the thing it wished to elucidate. The ancients had painted landscape as it appeared broadly at first glance. The Impressionists, being interested in nature as a manifestation in which light plays the all-important part, transferred it bodily onto canvas from that point of view.

Cézanne, looking into their habits more coolly, saw their restrictions. While achieving all their atmospheric aims, he went deeper into the mechanics of color, and with this knowledge achieved form as well as light. This was another step forward in the development of modern methods. With him color began to near its true and ultimate significance as a functioning element. Later, with the aid of the scientists, Chevreul, Superville, Helmholtz and Rood, other artists made various departures into the field of color, but their enterprises were failures. Then came Matisse, who made improvements on the harmonic side of color. But because he ignored the profounder lessons of Cézanne he succeeded only in the fabrication of a highly organized decorative art. Not until the advent of the Synchromists, whose first public exhibition took place in Munich in 1913, were any further crucial advances made. These artists completed Cézanne in that they rationalized his dimly foreshadowed precepts.

To understand the basic significance of painting it is necessary to revise our method of judgment. As yet no æsthetician has recorded a *rationale* for art valuation. Taine put forth many illuminating suggestions regarding the fundamentals of form, but the critics have paid scant heed. Prejudice, personal taste, metaphysics and even the predilections of sentiment, still govern the

world's judgments and appreciations. We are slaves to accuracy of delineation, to prettiness of design, to the whole suite of material considerations which are deputies to the organic and intellectual qualities of a work of art. It is the common thing to find criticisms—even from the highest sources—which praise or condemn a picture according to the nearness of its approach to the reality of its subject. Such observations are confusing and irrelevant. Were realism the object of art, painting would always be infinitely inferior to life—a mere simulacrum of our daily existence, ever inadequate in its illusion. The moment we attach other than purely æsthetic values to paintings—either ancient or modern—we are confronted by so extensive and differentiated a set of tests that chaos or error is unavoidable. In the end we shall find that our conclusions have their premises, not in the work of art itself, but in personal and extraneous considerations. A picture to be a great work of art need not contain any recognizable objects. Provided it gives the sensation of rhythmically balanced form in three dimensions, it will have accomplished all that the greatest masters of art have ever striven for.

Once we divest ourselves of traditional integuments, modern painting will straightway lose its mystery. Despite the many charlatans who clothe their aberrations with its name, it is a sincere reaching forth of the creative will to find a medium by which the highest emotions may most perfectly be expressed. We have become too complex to enjoy the simple theatre any more. Our minds call for a more forceful emotion than the simple imitation of life can give. We require problems, inspirations, incentives to thought. The simple melody of many of the old masters can no longer interest us because of its very simplicity. As the complicated and organized forces of life become comprehensible to us, we shall demand more and more that our analytic intelligences be mirrored in our enjoyments.

FOREWORDS

CHRISTIAN BRINTON

ROBERT HENRI

W. H. de B. NELSON

ALFRED STIEGLITZ

JOHN WEICHSEL

WILLARD HUNTINGTON WRIGHT

FOREWORD: BY CHRISTIAN BRINTON

IT is the contention of certain conservative, not to say congested, individuals that the European war has killed the new art. They repeat the assertion with an air of exultant confidence. Painters and public alike, they aver, will eagerly revert, once the current cataclysm has passed, to those comforting conventions which even they have been forced to admit were in imminent danger of being swept aside. It is obvious that such an attitude is not alone reactionary but cowardly. It is indeed a mere pitiful catching at the last fugitive straws that might save them from final submergence. In point of fact the war has in no sense extinguished the new art, nor could such possibly prove to be the case. Though a number of painters, sculptors, and architects have perforce turned to sterner tasks, the principles upon which æsthetic progress is based will survive, and will in due course take on fresh vigor and significance.

A singular lack of perspective characterizes those who assume that the changes which have lately taken place in the province of graphic and plastic production are of recent origin. Opponents of the new movement are in the habit of charging that it is a purely superficial and sporadic aberration which sprang into being overnight as it were. Nothing could be farther from fact. It is not Henri-Matisse whom we must thank for the present simplification of form and cult of flat color, nor can Manet be accurately described as the pioneer Expressionist. There were apostles of voluminal integrity before Cézanne, classicists imbued with archaic ardor before Gauguin went to Tahiti, and restless Gothic souls before Vincent forsook the grey mists of Flanders for the burning solar ecstasy of Arles. The modern movement is, it must ever be borne in mind, not a revolution, but the result of a more deliberate and definitive process of social as well as æsthetic evolution.

Unwelcome as the idea may prove in certain quarters, it is an indisputable fact that most phases of artistic expression were never meant to survive as creative impulses for more than a single generation. They may succeed in placing themselves upon permanent record, their influence may endure for centuries, yet

no matter how patent their truth and potency they do not merit the compliment of imitation or duplication. Avowedly to espouse at this date the classic point of view, the rococo point of view, or the flamboyant fervor of romanticism is to prove one's timidity and infertility of endowment. That which we cherish most of all in a work of art is the accent of its particular day and epoch. No purely technical achievement can compensate for the loss of this precious impress. And no artist out of sympathy with the psychology of his age can attain convincing self-expression.

It is superfluous here to offer an apologia for a phase of art which is to-day manifesting itself in such stimulating force and variety. To many it seems confused and inconclusive, yet it should not be forgotten that all this work is the outcome of identical causes. Art in its initial stages never was, and was never meant to be, merely imitative. It was an indication, rather than an imitation. As man however grew more adept and less imaginative, a gradual process of substitution took place. We were in due course given what was, as nearly as human ingenuity could fashion it, the actual object rather than its infinitely more suggestive sign or symbol. This debased and spiritually defunct form of illusionism, of trivial, *trompe l'œil* industry, has indeed been carried so far that the general public, and most of the artists themselves, have lost sight of the primary significance of æsthetic production. We have so long been taught that the chief function of art was to make a thing look as much as possible like itself that we have supinely accepted this uninspired viewpoint.

That there should have been periodic protests against this wholesale prostitution of the higher possibilities of artistic expression was inevitable. You may cite El Greco as a case in point, and you may mention Cézanne in the same connection, but never before in the annals of art has there been anything comparable to the widespread readjustment of aim and purpose which characterizes present-day effort. Everywhere are young men, and those not too decrepit to admit of growth and change, striking out along kindred lines. These several groups may give themselves abstruse and unfamiliar names, yet their work itself presents an aspect of convincing unity. They are one and all

striving to attain virtually the same end. They are seeking
freedom from convention and the cant of academic dogma. The
latitude of idiom may be considerable, but the language they are
struggling to enunciate is one of salutary independence and indi-
viduality.

Whether or not the new movement has thus far produced
anything of clarity or significance is a matter for the general pub-
lic to determine. If the public in any substantial degree endorses
this work, the battle for recognition will obviously be won. It
is however necessary, in confronting such relatively advanced
manifestations, to realize that these canvases portray not specific
objects but various states of creative consciousness as induced
by certain given combinations plastic, chromatic, or linear. Ab-
stract in spirit, they represent a series to æsthetic reactions
more complex than any hitherto encountered upon exhibition
wall, and yet, as it will possibly be seen, not less legitimate in
appeal.

It is absurd to accuse a large majority of the younger painters
of the day and not a few among their elders of stark madness
or wilful perversity. One must, in all justice, recognize the
sincerity of the new art and strive to comprehend its already
considerable achievement. Should its exponents not succeed in
placing to their credit anything approximating the sovereign
surety of a masterpiece, they will at least have done much. They
will have proved that painting is not a sterile pastime, but a
form of activity animated by the spirit of an always aspiring
unrest.

FOREWORD: BY ROBERT HENRI

I AM interested in this exhibition because I believe that it is better to see the works than to read what is written about them.

I believe in the development of individual criticism and appreciation.

I am so much interested in the development of individual judgment, believe so much in the necessity of individual judgment to the growth and pleasure of the individual, that I stand opposed to the finality of practically all art criticism and feel disposed to defend the picture against the critic whether he praises or whether he condemns.

The defence can only be made by putting the pictures themselves fairly before the public.

I have long advocated the establishment of galleries where small groups of artists, self-selected and self-organized, might have space on demand to present their works for public inspection, where the people would be invited to come, see, and in the act of personal judgment develop the taste that is latent in them, rather than accept the dictates of those who have assumed authority as juries of admission, juries of award, and critics.

I have no objection to the most liberal expression of opinion. I grant the critic his right to glorify or condemn, to announce his finalities and establish his standards of taste; to tell us as is so often his wont just who is the greatest artist and which is his best work and which is the best stroke on the work. It's his right and his pleasure. The more positive he is in his opinions the more interesting and perhaps the more instructive he is, provided, however, we are not swept away from our own judgment by the force of his edicts and his air of finality.

Of this I am certain, taste cannot be standardized and for the reason that artists, who are interested in the pursuit of fundamental principles, have taken different roads. All art that is worth while is a record of intense life and each individual artist's work is a record of his special effort, search, and findings in language especially chosen by himself and devised best to express him, and the significance of his work can only be understood by

careful study; no crack-judgment, looking for the expected, will do, nor can we be informed by the best critic, for appreciation is individual, differs with each individual and is an act of creation based on the picture which is an organization, not a mirror of the artist's vision; but the essential principle of it, and therefore of basic value to the creative impulse in the spectator.

I do not refer especially to the so-called modern art in this. It is true of all art whether old or new. All interesting developments in art have at first puzzled the public, and the best appreciators have had to suspend judgment during the period necessary for full consideration.

As to my impression of the works in the present exhibition, I will simply say that I like, enjoy and receive inspiration from many of them, I like many different kinds of painting. I like men best when they differ from each other and carry each one a note special to himself. I value the effect of these new notes on myself. I believe in constant revaluation.

To appreciate and get a great deal from a work of art does not mean to find the expected in it, nor does it mean, necessarily to accept or follow it wholly, in part, or at all. Every work is one man's vision, an outside experience, useful to us in our own constructions. The wisdom and the mistakes of the past are ours to build on, and the picture painted yesterday, now hanging on the wall, is already of the past and is a part of our heritage.

I regard the battlers for ideas and the builders of new roads with enthusiasm and reverence. Their works (the record of their struggles and findings) are things to watch and to cherish. This is the way I feel about the works of serious men whether they be of the past or of to-day.

I am not interested in any one school or movement, nor do I care for art as art. I am interested in life. The most we can desire of men is that they be master of such as they have, and then we should be highly satisfied with them, and regard them as neither less nor greater than any. Place them as themselves.

I claim for each one free speech, free hearing. I am interested in the *open forum*, open for every man to come with his word and for every man to come to hear the evidence, unticketed, unprejudiced by jury or critic.

I am opposed to any man or any body of men who assume the authority to pick, choose, and settle the question of what is good. I am opposed to an art jury when I am serving on it. I seek to destroy it by presenting at the time as far as I can my reasons to the reasoning minds of my fellows.

In all progress I believe that each man picks up the line of human development where he will and carries it where he will. He makes his record in flats or in solids, with whatever forms he chooses. His work is his evidence. If it is as strong as he is and as weak as he is, it is one man's truthful record and as such it is good.

FOREWORD: BY W. H. DE B. NELSON

RECENTLY at a theatrical performance a gentleman widely known as a comic singer had been invited to fill out a pause, and according to preconceived ideas he should in bounden duty have conformed with his custom, but he didn't. He selected a very sentimental song hallowed by Hayden Coffin entitled " Sunshine Above." The house commenced to smile before he had sung a bar, and by the end of the first stanza was convulsed with merriment. The violated feelings of the performer matter nothing. What does, however, matter is that the public insists on being spoon-fed. Convention has ever been the antagonist of truth. We love, honor and obey conventions because we are so desperately afraid of truth. To arrive at the truth of things demands a certain amount of thought; it also calls for sacrifice. We have to divest ourselves of the warm wraps of tradition and actually face in our nakedness new conditions which we find difficult to understand. We go to hear X and enjoy his fun. By what right does he become a pervert and disturb the programme? We go to laugh and we intend to laugh whatever happens.

As in life, so in painting. Whenever a current of art has run dry and some innovator in his insolence has attempted to remove obstacles and broaden the course, the fatuous public has always greeted such efforts with guffaws. From Christ to Rodin the experience has been the same. It is not customary to crucify an artist in prescribed fashion, but there are many ways of meting out a similar punishment. Neglect is the most potent weapon in use; neglect will soon reduce its victim from the Waldorf to the Automat, from comfort to despair.

The battle of art to-day is being as keenly contested as any battle in Europe, and reputations, if not men, go down in the process. Since 1848 the break from academic methods has been gathering in intensity; the lifeless amalgam of superb draughtsmanship is all the time yielding more and more to the living action so intensely summoned forth by the so-called impressionists. It is the age of the movie picture. So many currents of art have been dammed and damned through the inability of present-day artists to equal or improve upon the achievements of the past that

of necessity new currents of art are trickling along in a forma-
tive state, rivulets striving to be rivers.

Every one recalls the Armory Exhibition which was at once
a success and a fiasco. It was a success insomuch as it compelled
the public to do a little thinking and taught that same public
that much is being done with brush and chisel of a totally differ-
ent character to what the American galleries and exhibitions have
been accustoming us for many a decade. It was a fiasco for the
reason that a plethora of material selected at haphazard con-
fused the mind and failed to set any logical standards by which
modern work could be estimated. People laughed or tore their
hair according to temperament. The Armory exposition ended,
and a flabby, conventional verdict declared the end of modern
painting in New York. Verdicts, however, like reputations, are
in a state of flux, and to-day we find many signs that modern
painting, far from emulating that extinct bird, the dodo, is very
much alive and kicking. Exhibitions take place continually about
Fifth Avenue devoted entirely to the display of modern work.

A reaction has set in. The present exhibition is an honest
effort to separate the wheat from the tares, to show a repre-
sentative group of the best work of some twenty sincere artists
who ask for no favors beyond that the public should try and
see eye to eye with them and approach their canvases in a criti-
cal spirit free from prejudice and preformed opinion. In fact,
they claim an impartial hearing like any other prisoner in the
dock.

FOREWORD: BY ALFRED STIEGLITZ

THERE never has been more art-talk and seeming art-interest in this country than there is to-day. In my mind there is the constant question: Is the American really interested in painting as a life expression? Is he really interested in any form of art? Twenty-five years of concentrated study of the subject has resulted in my knowing that he is not. There may be a few rare exceptions.

To me art as it is looked upon in America to-day is the equivalent in society to what the appendix is to the human body. Scientists are still differing as to whether the appendix is of value or not to the human organism. We do know the human being can enjoy life without it.

Granting that the American looks upon painting as a necessary function of society, I feel that the system now in vogue of bringing the public into contact with the painting of to-day is basically wrong. The usual exhibition is nothing but a noise maker. It results in leading people *away* from the unadulterated spirit. It does not do what it is professedly to do: To bring about a closer Life between Expression and Individual.

This particular exhibition receives my co-operative support because the men represented in it should be given an opportunity to develop—to continue their experiments. To me many of their experiments are of value if anything in American painting is of consequence.

No public can help the artist unless it has become conscious that it is only through the artist that it is helped to develop itself. When that is once actually understood, felt, art in this country may have taken root.

The practical way to give the artist the opportunity to develop his work is to give him moral support backed up by sufficient means to live reasonably decently.

This holds good for all other workers besides artists.

FOREWORD: BY JOHN WEICHSEL

THE Forum Exhibition is not a bid for ordinary art-patronage. It is, rather, an attempt to make patronage quite extraordinary: to make it constructive.

There is a traditional aureole around art-patronage, presumably, an emanation of inherent virtues. Whatever these may be, constructiveness is not one of them. As a rule, art-patronage adds weight to long-established standards. Most often, it crushes art-growth by the preponderance it gives to dead roots. Only the " recognized " art is the object of ordinary patronage.

Neither can it be claimed for the usual sort of art-patronage that it is a free expression of individual taste. In truth, it is a docile submission to imposed notions on art-value, invariably emanating from doubtful æsthetic understanding and doubtless mercenary acumen. To the same sources can be traced the current dislike of the newer art. As a matter of self-preservation, the " authorities " whose claim to esteem (and remuneration) stands and falls with their obsolete standards, must trample down all new outcroppings in the field of art. But the most sinister effect of reactionary machinations is evident in the prevailing overestimation of classical art. Misled by the pompous authority of irresponsible theorizers, beguiled by the inflated prices of the speculators, deceived by the persistent clamor of didactic quacks, art-patronage has come to be a reckless expenditure of fabulous wealth and priceless enthusiasm upon an unparalleled indulgence in sterile ancestor-worship and traditional superstition, which inflict irreparable injury on our living day.

I believe it to be the most important duty of the art-world to stop the despoliation of our day in the name of past glories. Hence I welcome the Forum Exhibition of modern art as a means of restoring to our generation its rightful share of material and spiritual sustenance. I see in the work of the Forum Committee a strong protest against the customary blinding of our vision by everlasting flaunting before our eyes the over-furbished halo of traditional art. And I hope that this will lead to a general exposure of the fallacy of feeding a growing life

on the congealed froth of past ages. Meanwhile, I am looking
forward to a successful launching of this timely movement in the
Forum Exhibition. This enterprise of Mr. Willard Huntington
Wright, while not as complete as the leisurely prepared repeti-
tions of it are bound to be, is starting most auspiciously, Mr.
Wright having enlisted for his scheme the co-operation of the
Anderson Galleries—the focus of mighty potentialities.

To initiate the retrieval of patronage for the benefit of up-
to-date art expression, the Forum Committee have gathered to-
gether the best available portion of distinctly modern art. The
Committee have undertaken to free this art from the undeserved
odium thrown upon it by prejudice and ignorance. The very
headway made by this advanced art, removed it from the sus-
taining companionship of unprejudiced art-lovers. The very
progress it has achieved, discredited it in the eyes of the stagnant
conventionalists. The new truths it has revealed, brought con-
demnation from those who can see no truth beyond their own
catechism.

The new art was branded as bereft of primary æsthetic
principles. As a matter of fact, it neither overlooked nor ex-
cluded anything in the cardinal stock of art-creation. It has
turned the light of scientific research on the conventional equip-
ment of art. It has set its mind on all-inclusion rather than
exclusion. It has made careful and prolific use of the principles
of color-harmony, line-rhythm, space-division, mass-balance. But
it refused to acquiesce in the traditionally approved imposture—
the investiture of these forms of expression with the dignity of
noumenons. It is obvious to an unbiased eye that the maker
of the newest art is willing to employ the customary modes of
expression in the same measure in which a poet employs the
language-elements in his poetry, cadences, words, accents, rhymes,
etc. Still, the new artist is unwilling to be a draughtsman or a
painter or a modeller. Just so is a poet unwilling to be merely a
rhymester. Indeed, while bringing drawing, modelling and paint-
ing to a higher state of perfection in the many variegated proc-
esses, from Impressionism to Cubism, Post-Impressionism and
Synchromism, modern art avowedly seeks to pass beyond good
drawing, good modelling, good painting, and other forms of ex-

pression. It seeks to penetrate into the realm of " pure " art, although it does not discard the unavoidable forms of expression which conventional notion accepts as adequate ends of art. Modern art adopts these forms as the raw material for the building of a masterpiece, as ordered sensations gleaned by an artist from experience for the purpose of transmutation by the process of art. The ordered sensations are the common stock of human intelligence. One might say, they are the legal tender in the graphic business. Only in an artist's grasp, these sensory seizures of reality become the medium for an intensely personal annunciation. In fine, as far as is discernible at this stage of its evolution, the latest art aims at being in the plastic realm what poetry is in the verbal, and music in the tonal world: a sublime psychic entity incarnate.

Surely, no one ever approached art with greater reverence and qualification. The accusation of insufficient professional schooling is a malicious invention that is easily refuted by the ample evidence of æsthetic merit in the composition of the advanced works of art. Their purely decorative value—whatever the appeal of their content—will not fail eventually to secure for them an honored place in art-collections. They will be cherished as earnest attempts to do justice to the profundity of modern mentality and social complexity. They will command respect as valuable essays, deeply conceived and carried out with intense feeling, with external charm and inner beauty.

The Forum Exhibition is dedicated to this superior art and, through it, to the high mission of which the new art is a living token: the lifting of creativeness in art above dulling rut, debasing imitation, puerile stunt and technical futility. . . . It is a privilege of discerning art-lovers to share in this creative task by granting their active sympathies to the cause of living art.

FOREWORD: BY WILLARD HUNTING-TON WRIGHT

THE pictures in the present exhibition are adequately representative of the best work being done by the modern men in America. There is not a painting here which is not a genuine and sincere effort on the part of a conscientious artist to express some vital idea in the realm of the new æsthetics. Not one man represented in this exhibition is either a charlatan or a maniac; and there is not a picture here which, in the light of the new ideal, is not intelligible and logically constructed in accordance with the subtler and more complex creative spirit which is now animating the world of art.

It is true that there are a great many insincere men allied with the new movement—men who have fallen in line for commercial reasons and whose productions are worthless and discreditable. The public misunderstanding of modern art is due largely to the fact that in America there have been few critics who have conscientiously pointed the way. Our art writers for the most part have refused to give the matter any study, finding it less arduous and more popular to condemn all work which has had an aspect of newness. Also in the matter of exhibitions the public has been led astray. Insincere and insignificant modern painters have been exposed and held up as representative, while the truly deserving artists have received little or no publicity. When any large exhibition—such as the Armory show—has been presented to the public, the good has been mixed indiscriminately with the bad: there has been no attempt at differentiation; and the public, confused and misled, has fallen back on ridicule and condemned modern art as a whole.

In the present exhibition pains have been taken to include only that which is deserving and sincere and significant. To ridicule the pictures here on view can be only a confession of ignorance. All new excursions into the field of knowledge have been met with ridicule; but, despite that ridicule, the new has persisted, in time becoming the old and accepted. Throughout the entire evolution of painting this has been the case. But no one laughs any more at Monet, Pissarro, Manet, Dagas and Renoir, al-

though there was a time when each of these painters was con-
fronted with jibes and sneers.

I sincerely believe that the pictures, shown in this exhibition
will endure—that the day will come when they will not seem
bizarre and incomprehensible; and I further believe that if those
persons who are sincerely interested in painting will strive con-
scientiously to find their way into this new territory, instead of
scoffing and refusing to follow the artist in his complicated
efforts, they will in time arrive at a comprehension of this new
work.

Modern painting is not a fad: it is not a transient aspect of
art. Beginning with Constable, Turner, Delacroix, Daumier
and Courbet, it has progressed and developed logically for a
century. It is a direct result of ancient art. Basically the new
men are striving for nothing more than that for which the older
men strove; their methods and processes, however, are not so
obvious; and herein lies the difficulty of understanding them.

But bear this in mind:—the enduring qualities of the older
paintings—that is to say, those qualities which give them an
æsthetic emotion and make one old master greater than another
—are the precise qualities which are to be found in all significant
modern paintings. The unessentials have, in large part, been
eliminated. And, in addition, there have been advances made
in the means and methods of painting. Everyone knows, for
instance, that of two different Renaissance paintings of a Ma-
donna and Child, one may be a great piece of art while the other
may be artistically worthless. It is neither the subject-matter
nor the painter's approximation to nature which makes his work
great: it is the inherent æsthetic qualities of order, rhythm, com-
position and form.

Now, the modern men, in the main, are striving to divest
these fundamental qualities of all superficial matter, to state them
purely and, by so doing, to increase the emotional reaction of the
picture. True, it is difficult for the average untutored spectator
to recognize these qualities without the intermediary of recog-
nizable objectivity. But once he has adjusted his vision, he will
find that the pleasure he derives from modern painting will more

than compensate him from the intellectual effort he must exert before he can understand it.

Therefore, instead of dismissing the new work as incomprehensible and meaningless, let everyone who is interested in progress and intellectual effort try to find the beauty which is here manifest. It is not a new beauty, but an old beauty purified and given a new investiture. Only reactionary and static minds scoff antagonistically at the new and the strange. Every day intelligent men and women are coming in touch with the new vision of art. You yourself can find that vision if you will not attempt to approach it through the conventional channels of preconceived ideas, but will give it the serious critical attention it deserves. Scoffing and indifference will injure neither the modern artist nor his work. You alone will be the loser, for you will close to yourself the door which leads to the highest æsthetic emotion.

The pictures here shown give an unusual opportunity for coming into touch with the more important modern American painters. Each painter has been chosen for his sincerity and for the authority which attaches to his work. Likewise the paintings themselves have been chosen because each represents a definite attainment in the new field of æsthetic endeavor. You need have no fear as to the genuine merit of every picture hung. The Committee, which is responsible for this exhibition, comprises men of varied tastes—men who have given years to the study of art's development and who are ready to vouch for the worth of every canvas present.

EXPLANATORY NOTES

BEN BENN

THOMAS H. BENTON

OSCAR BLUEMNER

ANDREW DASBURG

ARTHUR G. DOVE

MARSDEN HARTLEY

S. MACDONALD-WRIGHT

JOHN MARIN

ALFRED MAURER

HENRY L. McFEE

GEORGE F. OF

MAN RAY

MORGAN RUSSELL

CHARLES SHEELER

A. WALKOWITZ

WILLIAM ZORACH

L IKE most students I was first attracted to groups of painters rather than artists. The actual ability to paint well was the first aim of my student days. From an admiration of Meissonier, Bouguereau and Gérôme, I went to more profound men, such as Rembrandt, Van Dyke, Teniers and still later to the Spaniards. These men all taught me the necessity of craft mastery and the love of the actual textural surface of the canvas.

Perhaps it was the tactilely pleasing surfaces seen in the Impressionists that attracted me to this latter metamorphosis. Their use of color made the achievement of divergency of material more extended, which divergency, I hold, is absolutely necessary in avoiding monotony of uniform surfaces.

Then I saw the modern masters, and they, more than the old, opened my eyes to the necessity for something of more permanent value—interdependence of parts (called organization), pattern (the just disposition of masses), and rhythm to unite these other elements. Indeed, these preoccupations I deem of primary importance, and I believe they should be the first consideration of the creative artist. An ability to master them is what differentiates the great art of the past and present from the merely competent.

Color should be used always harmoniously to give to the spectator what the artist has felt before his subject, though it need not be necessarily a replica of this subject.

I put in my work only the selected essentials of my inspiration, desiring, above all, that my work shall be direct. This I try to obtain by continually editing the first impression until I feel that all unessentials have been eliminated. *Ben Benn.*

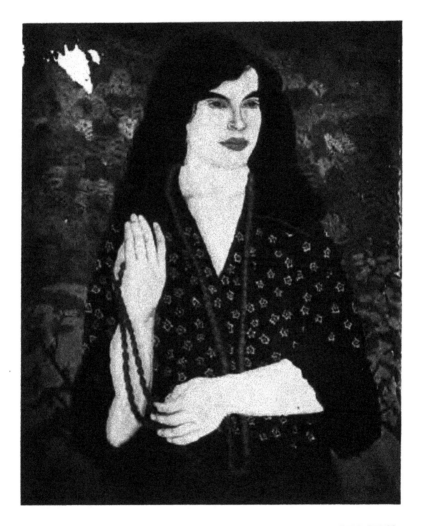

FIGURE BEN BENN

MY experience has proved the impracticability of depending upon intellectualist formulas for guidance, and I find it therefore impossible to ally myself definitely with any particular school of æsthetics, either in its interpretative or constructive aspects.

I may speak generally of my aim as being toward the achievement of a compact, massive and rhythmical composition of forms in which the tactile sensations of alternate bulgings and recessions shall be exactly related to the force of the line limiting the space in which these activities take place. As the idea of form cannot be grasped without mental action on the part of the beholder; as its comprehension, that is, implies the necessity of a more intense mental state than is requisite for the enjoyment of simple loveliness of color, I value its development, manipulation, etc., as by far the most important element entering into the construction of a work of art.

The generation of the idea of form depends upon a comparison of contoural or linear extensions, their force, direction and the like; this generation is caused by attention to boundaries of shapes; the pre-eminent stimulus to realizing a cubic existence is line—therefore I make the production of interesting line relations the first business in my painting. Color I use simply to reinforce the solidity and spacial position of forms predetermined by line.

I believe the importance of drawing, of line, cannot be overestimated, because of its above-mentioned control of the idea of form, and I believe that no loveliness of color can compensate for deficiency in this respect. While considering color of secondary constructive importance, I realize, nevertheless, its value in heightening the intensity of volume, and am, to a certain extent, in accordance with all those developments which, emanating from Cézanne, tend to accentuate its functioning power.

I believe that particular attention to consistency in method is bad, and for this reason employ any means that may accentuate or lessen the emotive power of the integral parts of my work.

In conclusion I wish to say that I make no distinctions as to the value of subject-matter. I believe that the representation of objective forms and the presentation of abstract ideas of form to be of equal artistic value.

Thomas H. Benton.

FIGURE ORGANIZATION NO. 3 THOMAS H. BENTON

ANY new work of art explains and reveals itself only to that degree that the spectator is unprejudiced and receptive. Indeed, a picture ought not to be and cannot be fully explained. Rather must explanation needs be obscure, so that the spectator may try to explain to himself the explanation by the aid of the pictures. Then these will the sooner become lucid to him.

The painter to-day as formerly in an ethical sense aims at a liberation of feelings. Only the ideas of the present age create emotions wanting liberation through expression in form and beauty that are different from those of the past and are more varied; because man's intellect progresses, widens, deepens. Hence the arts also become more manifold and freer, less bound by traditional and antiquating points of view.

Why then should American painting be limited by either old canons or any single new "ism"? We have a climate and a mind of our own,—greater intellectual freedom demands for its pictorial expression a corresponding freer use of line, form, tone and color. The only law a picture must conform to is that which it carries within itself, instead of submitting to rules from without; just as true art springs from within, while that which is caused from without is imitation.

The intensity and purity of this character of modern painting is greater than it was in by-gone art, so that we have even come to speak of abstract painting. Whatever inner impulse we address towards nature is abstract. Thus a landscape, as a motive for expression, undergoes a free transformation from objective reality to a subjective realization of personal vision. Thus the forms, tones, colors we call natural are so changed that the painting harmoniously corresponds to the idea by which it is inspired. Any pictorial idea imposes upon the process of transformation only one law—that of harmony. Hence painting may be as varied and novel, as characteristic and personal, as music is: free, bound only to its own inner laws.

Oscar Bluemner.

IMPRESSIONS OF A SILK
TOWN IN NEW JERSEY

OSCAR BLUEMNER

I N these pictures my intention has been to co-ordinate color and contour into a phantastic of form that will have the power to stimulate one's sense of the æsthetic reality.

In my use of color I aim to reinforce the sensation of light and dark, that is, to develop the rhythm to and from the eye by placing on the canvas the colors which, by their depressive or stimulating qualities, approach or recede in accordance with the forms I wish to approach or recede in the rhythmic scheme of the pictures. Thus the movement of the preconceived rhythm is intensified. This is what I mean by co-ordinating color and contour.

My conception of rhythm is based on a simple tensional contrast of lines which will give the sense of poise, of balanced masses which in themselves constitute an interdependent unity. The other lines—the minor rhythms—are developed from the original lines: they supplement and augment the first simple statement of the rhythm, and are, in turn, a part of the original rhythm, partaking of its character. Like leaves thrown in a stream, the minor rhythms are picked up by the central current and carried forward according to the direction of that current.

I differentiate the æsthetic reality from the illustrative reality. In the latter it is necessary to represent nature as a series of recognizable objects. But in the former, we need only have the *sense* or *emotion* of objectivity. That is why I eliminate the recognizable object. When the spectator sees in a picture a familiar form, he has associative ideas concerning that form which may be at variance with the *actual* relation of the form in the picture: it becomes a barrier, or point of fixation, standing between the spectator and the meaning of the work of art. Therefore, in order to obtain a pure æsthetic emotion, based alone on rhythm and form, I eliminated all those factors which might detract the eye and interest from the fundamental intention of the picture.

Andrew Dasburg.

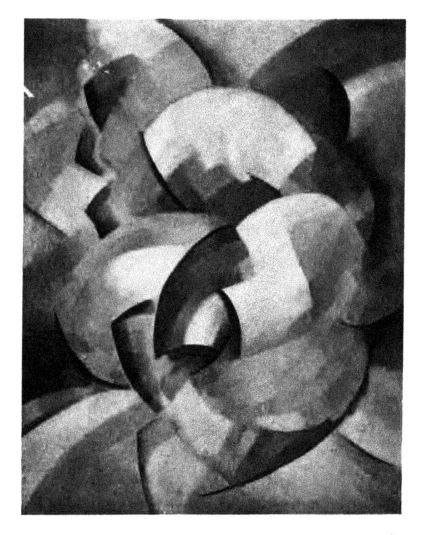

IMPROVISATION ANDREW DASBURG

I SHOULD like to enjoy life by choosing all its highest instances, to give back in my means of expression all that it gives to me: to give in form and color the reaction that plastic objects and sensations of light from within and without have reflected from my inner consciousness. Theories have been outgrown, the means is disappearing, the reality of the sensation alone remains. It is that in its essence which I wish to set down. It should be a delightful adventure. My wish is to work so unassailably that one could let one's worst instincts go unanalyzed, not to revolutionize nor to reform, but to enjoy life out loud. That is what I need and indicates my direction.

Arthur G. Dove.

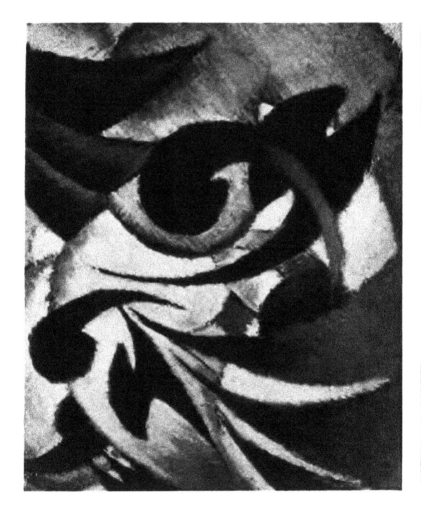

ARTHUR G. DOVE

NATURE SYMBOLIZED

PERSONAL quality, separate, related to nothing so much as to itself, is a something coming to us with real freshness, not traversing a variety of fashionable formulas, but relying only upon itself. The artist adds something minor or major more by understanding his own medium to expression, than by his understanding of the medium or methods of those utterly divergent from him. Characteristics are readily imitable; substances never; likeness cannot be actuality. Pictural notions have been supplanted by problem, expression by research. Artistry is valued only by intellectualism with which it has not much in common. A fixed loathing of the imaginative has taken place: a continual searching for, or hatred of, subject-matter is habitual, as if presence or absence of subject were a criterion, or, from the technical point of view, as if the Cézannesque touch, for instance, were the key to the æsthetic of our time, or the method of Picasso the clew to modernity.

I am wondering why the autographic is so negligible, why the individual has ceased to register himself—what relates to him, what the problematic for itself counts. I wonder if the individual psychology of El Greco, Giotto and the bushmen had nothing to do with their idea of life, of nature, of that which is essential—whether the struggle in El Greco and Cézanne, for example, had not more to do in creating their peculiar individual æsthetic than any ideas they may have had as to the pictural problem. It is this specialized personal signature which certainly attracts us to a picture—the autographic aspect or the dictographic. That which is expressed in a drawing or a painting is certain to tell who is its creator. Who will not, or cannot, find that quality in those extraordinary and unexcelled watercolors of Cézanne, will find nothing whatsoever anywhere. There is not a trace anywhere in them of struggle to problem: they are expression itself. He has expressed, as he himself has said, what was his one ambition—that which exists between him and his subject. Every painter must traverse for himself that distance from Paris to Aix or from Venice to Toledo. Expression is for one knowing his own pivot. Every expressor relates solely to himself—that is the concern of the individualist.

It will be seen that my personal wishes lie in the strictly pictural notion, having observed much to this idea in the kinetic and the kaleidoscopic principles. Objects are incidents: as apple does not for long remain an apple if one has the concept. Anything is therefore pictural; it remains only to be observed and considered. All expression is illustration—of something.

Marsden Hartley.

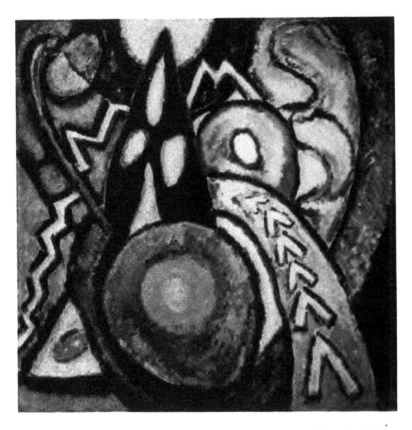

MOVEMENT MARSDEN HARTLEY

I STRIVE to divest my art of all anecdote and illustration, and to purify it to the point where the emotions of the spectator will be wholly æsthetic, as when listening to good music.

Since plastic form is the basis of all enduring art, and since the creation of intense form is impossible without color, I first determined, by years of color experimentation, the relative spatial relation of the entire color gamut. By placing pure colors on recognizable forms (that is, by placing advancing colors on advancing objects, and retreating colors on retreating objects), I found that such colors destroyed the sense of reality, and were in turn destroyed by the illustrative contour. Thus, I came to the conclusion that color, in order to function significantly, must be used as an *abstract medium.* Otherwise the picture appeared to me merely as a slight, lyrical decoration.

Having always been more profoundly moved by pure rhythmic form (as in music) than by associative processes (such as poetry calls up), I cast aside as nugatory all natural representation in my art. However, I still adhered to the fundamental laws of composition (placements and displacements of mass as in the human body in movement), and created my pictures by means of color-form which, by its organization in three dimensions, resulted in rhythm.

Later, recognizing that painting may extend itself into time, as well as being a simultaneous presentation, I saw the necessity for a formal climax which, though being ever in mind as the final point of consummation, would serve as a *point d'appui* from which the eye would make its excursions into the ordered complexities of the picture's rhythms. Simultaneously my inspiration to create came from a visualization of abstract forces interpreted, through color juxtapositions, into terms of the visual. In them was always a goal of finality which perfectly accorded with my felt need in picture construction.

By the above one can see that I strive to make my art bear the same relation to painting that polyphony bears to music. Illustrative music is a thing of the past: it has become abstract and purely æsthetic, dependent for its effect upon rhythm and form. Painting, certainly, need not lag behind music.

S. Macdonald-Wright.

ORGANIZATION, 5 S. MACDONALD-WRIGHT

THESE works are meant as constructed expressions of the inner senses, responding to things seen and felt. One responds differently toward different things: one even responds differently toward the same thing. In reality it is the same thing no longer; you are in a different mood, and it is in a different mood.

If you follow a certain path you come to a something. The path moves towards direction, and if you follow direction you come to the something; and the path also is through something, under something and over something. And these somethings you either respond to or you don't. There are great movements and small movements, great things and small things— all bearing intimacy in their separations and joinings. In all things there exists the central power, the big force, the big movement; and to this central power all the smaller factors have relation.

Thus it is in life. Life is like a path which one follows. All things one meets are relative and interdependent. They may be good or bad, but they are never perfect. It is the same with the artist's expression: it, too, may be good or bad, but it is never perfect.

However, the paths and the factors of life may broaden. They may become more and more revealing. Some may travel and find, others may travel and never find the things relative to them. Thus the journey may be sensed or not sensed, expressed or not expressed.

So, in all human consciousness there are the seekers and those who do not seek, the finders and those who do not find.

Coming down to my work, you have these pictures. They are the products of a seeker or a finder, or of a man who neither seeks nor finds.

John Marin.

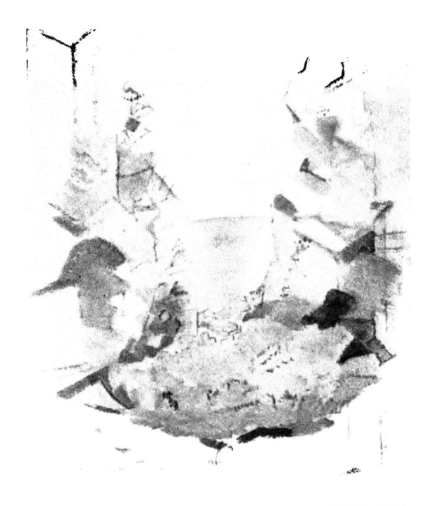

LANDSCAPE JOHN MARIN

MY main concern in painting is the beautiful arrangement of color values—that is, harmonized masses of pigment, more or less pure.

For this reason, it is impossible to present an exact transcription of nature, for the color masses in nature are broken up by many minute color notes which tend to eliminate the mass effect. Consequently, I often use the dominating color in a natural object, and ignore the minor notes. By this process the natural *effect* is retained, and at the same time the picture becomes a color entity divorced from mere representation: and I have acquired a volume of color which will take its place in the conception of the picture. This, of course, would be lost if all the details were truthfully set down: the many inconsequent aspects of an object would detract the eye from the final and pure effect of the work.

In order that I may express myself through the medium of color alone, I have eliminated, as far as possible, the sombre effect of black masses, and have keyed my pictures in a high articulation, so that the reaction to them will be immediate and at the same time joyous and understandable. Black, I believe, has a deadening effect in a pure color gamut, and I am trying to express the emotional significance of a scene without it, for pure colors are more moving than black, which is a negation of color.

It is necessary for art to differ from nature, or we would at once lose the *raison d'être* of painting. Perhaps art should be the intensification of nature; at least, it should express an inherent feeling which cannot be obtained from nature except through a process of association. Nature, as we all know, is not consciously composed; and therefore it cannot give us a pure æsthetic emotion. I believe that the artist who paints before nature should order his canvases; and in doing this he is unable to adhere exactly to the scene before him. The principles of organization and form, which animated the older painters, must not be ignored. They form the true basis for artistic appreciation. But the modern men can make use of these principles through a different medium. He can find a new method of presentation.

The artist must be free to paint his effects. Nature must not bind him, or he would have to become more interested in the subject-matter before him than in the thing he feels need expression. In my case, where I am interested in the harmonic relation of color volumes, I consider the tonal values first. This is why my pictures differ from the scene which they might seem to represent.

Alfred Maurer.

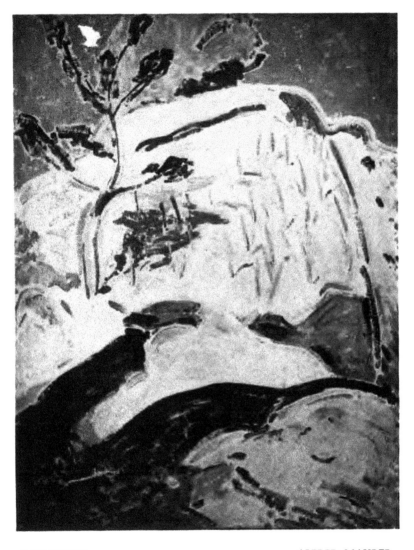

LANDSCAPE ALFRED MAURER

I AM endeavoring, by analysis, to find the essential planes of the emotional form of my motif, and to realize these planes by right placing of color and line, and by such a just relation of shape to shape, that the canvas will be, when completed, not a representation of many objects interesting in themselves, but a plastic unit expressive of my understanding of the form-life of the collection of objects.

Henry L. McFee.

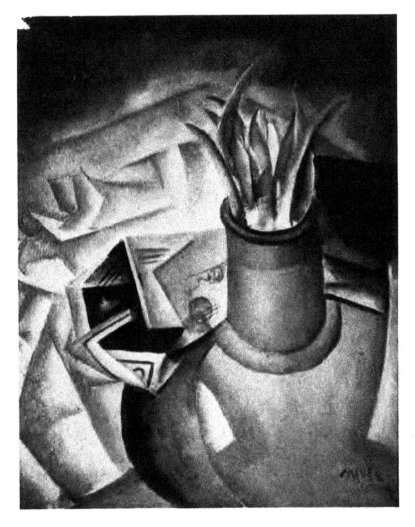

STILL-LIFE HENRY L. MCFEE

TO create art it is necessary to have had an inspiration, and this takes place only when one reacts æsthetically to certain groupings of color and form. Why these groupings move us is inexplicable, although the ability to translate our emotions before them onto a canvas must be the result of intelligence in the painter. Essaying the exact reproduction of them only leads to an inorganic and chaotic mass of data.

To make the canvas live a life of its own, irrespective of its inspiration, is my aim; and this can only be accomplished by him who perceives the causes underlying the life of his subject.

When I go to the museum and see great paintings, I forget the material things which they represent. It is not the appearance of external form that makes great art; it is the love of the master for his work that speaks to me, the profundity of his insight into the philosophy of his art which is synonymous with life that impresses me. It is a quality, a force, akin to what one feels in listening to great music, which touches the heart and transports the soul, but which in its ultimate essence cannot be defined —only felt.

Still this spirit must have a medium of conveyance or it could not manifest itself to us, and that vehicle is the tangible form which has life, the appearance of nature.

The problem of the painter is to convey from the picture to the spectator an impression analogous to the one he received from nature, plus his own temperamental vision. For this purpose he is obliged, at least to begin with, to have a system by which he adapts the impression from nature to the materials at his disposal. When he has mastered his personal means he becomes unconscious of them.

We see that everything in nature bears a relation to some other thing— no effect without cause—an elaborate system of relations. We must retain the spirit of this system of relations in our picture because it corresponds to the unity that we perceive in nature. As far as our reason permits, everything is planned from the beginning. The greatest art was produced by a great love of creating beauty—a great mind and a great sincerity.

I have tried to solve the problem of producing form by means of pure color, my ambition being to create a thing of joy.

George F. Of.

THE OLD HOUSE GEORGE F. OF

THROUGHOUT time painting has alternately been put to the service of the church, the state, arms, individual patronage, nature appreciation, scientific phenomena, anecdote and decoration.

But all the marvelous works that have been painted, whatever the sources of inspiration, still live for us because of absolute qualities they possess in common.

·The creative force and the expressiveness of painting reside materially in the color and texture of pigment, in the possibilities of form invention and organization, and in the flat plane on which these elements are brought to play.

The artist is concerned solely with linking these absolute qualities directly to his wit, imagination and experience, without the go-between of a " subject." Working on a single plane as the instantaneously visualizing factor, he realizes his mind motives and physical sensations in a permanent and universal language of color, texture and form organization. He uncovers the pure plane of expression that has so long been hidden by the glazings of nature imitation, anecdote and the other popular subjects.

Accordingly the artist's work is to be measured by the vitality, the invention and the definiteness and conviction of purpose within its own medium. ,

Man Ray.

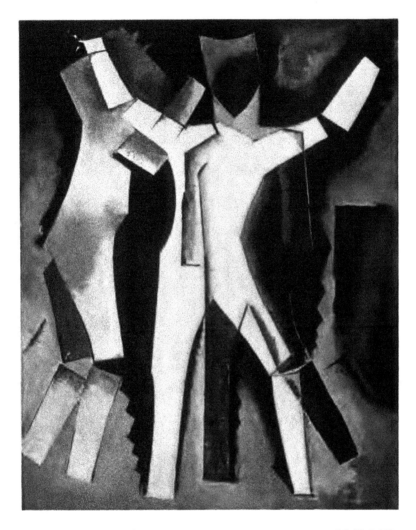

INVENTION—DANCE **MAN RAY**

MY first synchromies represented a personal manner of visualizing by color rhythms; hence my treatment of light by multiple rainbow-like color-waves which, expanding into larger undulations, form the general composition.

In my next step I was concerned with the elimination of the natural object and with the retention of color rhythms. An example of this period is the *Cosmic Synchromy*. The principal idea in this canvas is a spiralic plunge into space, excited and quickened by appropriate color contrasts.

In my latest development I have sought a " form " which, though necessarily archaic, would be fundamental and permit of steady evolution, in order to build something at once Dionysian and architectural in shape and color.

Furthermore I have been striving for a greater intensity of pictorial aspect. In the Middle Ages cathedral organs were louder than the sounds then heard in life; and men were made to feel the order in nature through the dominating ordered notes of the organ. But to-day the chaotic sounds and lights in our daily experience are intenser than those in art. Therefore art must be raised to the highest intensity if it is to dominate life and give us a sense of order.

Much has been said concerning the rôle of intellect in painting. Common-sense teaches that the mind's analytic and synthetic powers, like vigorous draughts of fresh air, kill the feeble and invigorate the strong. The strong assimilate the suggestions of reason to their creative reactions: the feeble superimpose reason on their pictures, thus petrifying their work and robbing it of any organic unity. This unity is a necessity to all great art and results only from a creative vision handling the whole surface with supple control.

I infuse my own vitality into my work by means of my sense of relations and adjustments. The difference between a picture produced by precise formulas and one which is the result of *sensibilité,* is the difference between a mechanical invention and a living organism.

While there will probably always be illustrative pictures, it cannot be denied that this century may see the flowering of a new art of forms and colors alone. Personally, I believe that non-illustrative painting is the purest manner of æsthetic expression, and that, provided the basic demands of great composition are adhered to, the emotional effect will be even more intense than if there was present the obstacle of representation. Color is form; and in my attainment of abstract form I use those colors which optically correspond to the spatial extension of the forms desired.

Morgan Russell.

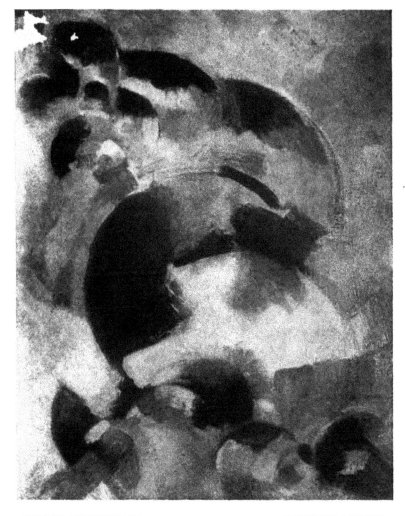

COSMIC SYNCHROMY MORGAN RUSSELL

I VENTURE to define art as the perception through our sensibilities, more or less guided by intellect, of universal order and its expression in terms more directly appealing to some particular phase of our sensibilities.

The highest phase of spiritual life has always in one form or another implied a consciousness of, and, in its greatest moments, a contact with, what we feel to be the profound scheme, system or order underlying the universe; call it harmonics rhythm, law, fact, God, or what you will.

In my definition I used the expression " through our sensibilities more or less guided by our intellects," and I here add "less rather than more," for I believe that human intellect is far less profound than human sensibility; that every thought is the mere shadow of some emotion which casts it.

Plastic art I feel to be the perception of order in the *visual* world (this point I do not insist upon) and its expression in purely plastic terms (this point I absolutely insist upon). So that whatever problem may be at any time any particular artist's point of departure for creative æsthetic endeavor, or whatever may be his means of solving his particular problem, there remains but one test of the æsthetic value of a work of plastic art, but one approach to its understanding and appreciation, but one way in which it can communicate its most profound significance. Once this has been established the observer will no longer be disturbed that at one time the artist may be interested in the relation of straight lines to curved, at another in the relation of yellow to blue or at another in the surface of brass to that of wood. One, two or three dimensional space, color, light and dark, dynamic power, gravitation or magnetic forces, the frictional resistance of surfaces and their absorptive qualities, all qualities capable of visual communication, are material for the plastic artist; and he is free to use as many or as few as at the moment concern him. To oppose or relate these so as to communicate his sensations of some particular manifestation of cosmic order—this I believe to be the business of the artist.

· *Charles Sheeler.*

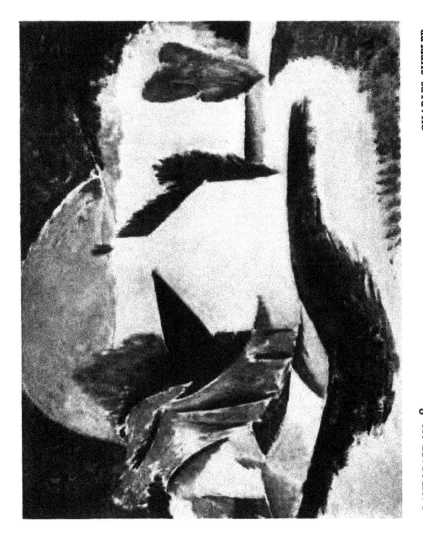

LANDSCAPE NO. 8 CHARLES SHEELER

WHAT one picks up in the course of years by contact with the world must in time incrust itself on one's personality. It stamps a man with the mark of his time. Yet it is, after all, only a dress put on a man's own nature. But if there be a personality at the core then it will mould the dress to its own forms and show its humanity beneath it.

In speaking of my art, I am referring to something that is beneath its dress, beneath objectivity, beneath abstraction, beneath organization. I am conscious of a personal relation to the things which I make the objects of my art. Out of this personal relation comes the feeling which I am trying to express graphically. I do not avoid objectivity nor seek subjectivity, but try to find an equivalent for whatever is the effect of my relation to a thing, or to a part of a thing, or to an afterthought of it. I am seeking to attune my art to what I feel to be the keynote of an experience. If it brings to me a harmonious sensation, I then try to find the concrete elements that are likely to record the sensation in visual forms, in the medium of lines, of color shapes, of space division. When the line and color are sensitized, they seem to be alive with the rhythm which I felt in the thing that stimulated my imagination and my expression. If my art is true to its purpose, then it should convey to me in graphic terms the feeling which I received in imaginative terms. That is as far as the form of my expression is involved.

As to its content, it should satisfy my need of creating a record of an experience.

A. Walkowitz.

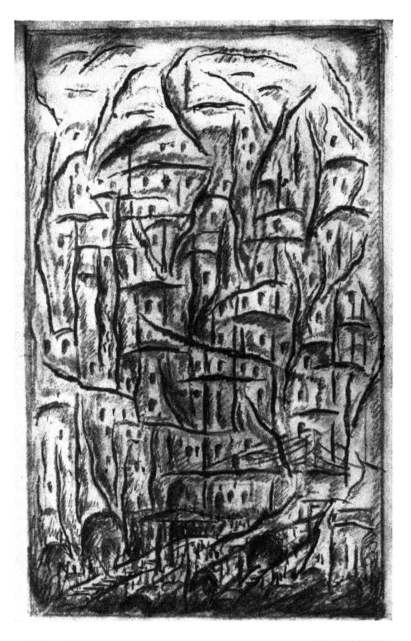

NEW YORK A. WALKOWITZ

IT is the inner spirit of things that I seek to express, the essential relation of forms and colors to universal things. Each form and color has a spiritual significance to me, and I try to combine those forms and colors within my space to express that inner feeling which something in nature or life has given me.

The moment I place one line or color upon my canvas, that moment I feel the need of other lines and colors to express the inner rhythm. I am organizing a new world in which each form and color exists and lives only in so far as it has a meaning in relation to every other form and color in that space.

In the spring one feels the freshness of young growing things, the ascending stream of life, the expanding of leaves and trees, the spirit and passions in the lives and volumes of rolling hills. All these are wonderful forms that act and react upon each other like sounds from a violin. I see the young child and its mother, I see the flowers, the birds, the young calf born in the field. I see the young calf prancing and feel the wild blood rushing through his veins. Then again, it is the strangeness of mountains, their bigness and solemnness and depth, their height, and the strange light upon them. I go into a farm house; the people sit silently around the room, a girl picks foolish tunes from a zither, the old feeble-minded grandfather wanders from window to window asking for the sun. And in all these things there is a bigger meaning, a certain great relation to the mountains and to the primary significance of life. One feels the relation of the forms of birds, flowers, animals, trees, of everything that grows and breathes to each other and to the earth and sky.

This I get from the world about me, and this I seek to give back again through my pictures.

William Zorach.

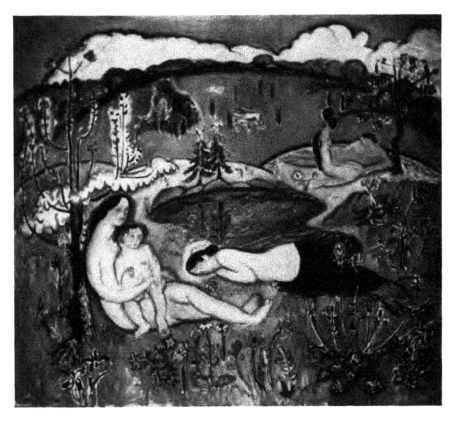

SPRING WILLIAM ZORACH

BIBLIOGRAPHY

BOOKS

Bell, Clive. *Art.* Frederick A. Stokes, Pub.

Wright, Willard Huntington. *Modern Painting: Its Tendency and Meaning.* John Lane, Pub.

ARTICLES

Aisen, Maurice. *The Latest Evolution in Art.* Camera Work (Special Number), June, 1913.

Brinton, Christian. *Evolution, Not Revolution, in Art.* International Studio, Apr., 1913.

Brinton, Christian. *The Modern Spirit in Contemporary Painting.* Introductory essay in *Impressions of the Art at the Panama-Pacific Exposition.* John Lane, Pub.

Bluemner, Oscar. *Some Plain Sense on the Modern Art Movement.* Camera Work (Special Number), June, 1913.

Bluemner, Oscar. *Walkowitz.* Camera Work, No. 44, Oct., 1913.

Buffet, Gabriele. *Modern Art and the Public.* Camera Work (Special Number), June, 1913.

Caffin, Charles H. *Henri Matisse and Isadore Duncan.* Camera Work, No. 25, Jan., 1909.

Caffin, Charles H. *Maurer and Marin at the Photo-Secession Gallery.* Camera Work, No. 27, July, 1909.

Caffin, Charles H. *The New Thought Which Is Old.* Camera Work, No. 31, July, 1910.

Caffin, Charles H. *A Note on Paul Cézanne.* Camera Work, Nos. 34 and 35, 1911.

De Zayas, Marius. *Modern Art—Theories and Representation.* Camera Work, No. 44, Oct., 1913.

De Zayas, Marius. *The New Art in Paris.* Camera Work, Nos. 34 and 35, 1911. Also The Forum, Feb., 1911.

De Zayas, Marius. *Pablo Picasso.* Camera Work, Nos. 34 and 35, 1911.

De Zayas, Marius. *Photography.* Camera Work, No. 41, Jan., 1913.

De Zayas, Marius. *A Study of the Modern Evolution of Plastic Art.* (With Paul B. Haviland.) "291," 1913.

De Zayas, Marius. *The Sun Has Set.* Camera Work, No. 39, July, 1912.

Haviland, Paul B. *A Study of the Modern Evolution of Plastic Art.* (With Marius De Zayas.) Camera Work, No. 39, July, 1912.

Weber, Max. *The Fourth Dimension from a Plastic Point of View.* Camera Work, No. 31, July, 1910.

Weichsel, John. *Artists and Others.* Camera Work, No. 46, Apr., 1914.

Weichsel, John. *Cosmism and Amorphism.* Camera Work, Nos. 42 and 43, July, 1913.

77

Weichsel, John. *Rampant Zeitgest.* Camera Work, No. 44, Oct., 1913.

Wright, Willard Huntington. *An Abundance of Modern Art.* The Forum, Mar., 1916.

Wright, Willard Huntington. *The Æsthetic Struggle in America.* The Forum, Feb., 1916.

Wright, Willard Huntington. *Art, Promise, and Failure.* The Forum, Jan., 1916.

Wright, Willard Huntington, *Cézanne.* The Forum, July, 1915.

Wright, Willard Huntington. *Impressionism to Synchromism.* The Forum, Dec., 1914.

Wright, Willard Huntington. *Modern American Painters—and Winslow Homer.* The Forum, Dec., 1915.

Wright, Willard Huntington. *Modern Painting.* Reedy's Mirror, Aug. 20, 1915.

Wright, Willard Huntington. *Paul Cézanne.* International Studio, Feb., 1916.

Wright, Willard Huntington. *Synchromism.* International Studio, Oct., 1915.

Wright, Willard Huntington. *The Water-Colours of John Marin.* International Studio, Mar., 1916.

*A*S a unit of the public, an art buyer, an art student and one interested in the art development of the country, I ask you, Mr. Wright, Dr. Brinton, Mr. Stieglitz, Dr. Weichsel, Mr. Nelson and Mr. Henri, to qualify for the position you have assumed and to answer the following questions—

Why are these two hundred paintings "the very best examples of modern American art"?

Why are they American, what element or elements, quality or qualities, do they possess that make them American?

What is the difference between "modern American art" and "modern European art"?

Why "turn public attention for the moment from modern European art"?

Why not turn public attention to art?

Do you mean "by guaranteeing, as it were, the authenticity and conscientiousness of the paintings shown" that you guarantee them as works of art?

Will you really "make the buyer feel secure" by guaranteeing the market value of these paintings?

At the end of five years will these two hundred paintings or any part of them be worth the price to you that is being asked for them to-day, and will you legally guarantee it?

I challenge all of you and each of you to back up your "critical selection" with proof.

WASHINGTON SQUARE GALLERY,

per R. J. Coady.